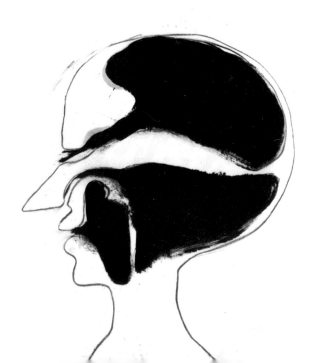

ANTONY GORMLEY

SALVATORE ALA

NEW YORK 1984

English language edition of 1,000 copies
Coracle Press, London

Printed in England

The image is for me an idea, which doesn't become good until it has physicality.[1]

All visible things are emblems; what thou seest is not there on its own account; strictly taken is not there at all: matter exists only spiritually and to represent some *idea* and body it forth.[2]

The present climate has encouraged many artists to engage with a heightened sense of urgency in an art that is orientated less to its own history than to the world around it. The means by which such themes are tackled are various and diverse; however, for many it has required a return to figuration. Some artists work directly from their immediate experience in order to project a reality which may be either wilfully private or assertively public, or a synthesis of the two. By contrast, others investigate reality as an effect rather than as the source of representation: this often leads to an art that explores the mediations of the real. All take the mind, its imaginative and/or rational powers, as their point of departure.[3] Few have argued that all information depends ultimately on something more rudimentary and immediate – the human body, its functions and mechanisms.

Just as the choice of subject matter has become a focus of debate so has the spirit in which these issues are broached. Feints, oblique and elliptical asides are now commonplace, as if only a stance that presupposes mockery, irony and sceptical disparagement can be valid. Undoubtedly, the heroic diction of the immediate postwar years with its concern for 'authenticity', 'commitment' and a tragic vision has, with hindsight, an innocent even naive aura, yet a direct, unqualified and unabashed engagement with a significant subject is seldom found. Given this ambience of self-conscious sophistication, Antony Gormley's aesthetic and

ambition are at once disarmingly straightforward and unexpectedly bold:

> I am now trying to deal with what it feels like to be a human being. To make an image
> that in some ways comes close to my states of mind. My body is my closest experience of
> matter and I use it for both convenience and precision. I can manipulate it both from
> within and without. I want to recapture for sculpture an area of human experience
> which has been hidden for a while. It is to do with very simple things – what it feels like
> to look out and see, what it feels like to be cold or frightened, or what it feels like to be
> absolutely quiet and just aware of the passage of air around your body...[4]

Consequently, Gormley's art largely divests itself of particular references to the art of the past. Equally, it does not attempt to realise its credo from within, that is by means of an examination of the medium itself, by addressing itself to questions of sculptural definition and innovation:

> immediate cultural references and certainly references to other forms of art rather than
> being the inspiration of new art can become the subject of the work – and a recondite
> language whereby the cognoscenti are made to feel that they are sharing a special
> experience, I'm not interested in that. I'm tired of art about art.[5]

In the past two years Gormley has concentrated increasingly on the motif of the human body as the vehicle through which to make an art that explores questions which are essentially spiritual, rather than emotional and material. For him Gauguin's *Where do we come from? What are we? Where are we going?* succinctly poses these quintessential questions. He argues that man is not firstly a social and cultural animal but a physical being through whose body and senses all experience is mediated. But bodily experiences never remain at the level of physical sensations but through introspection and meditation attain a spiritual dimension. In choosing this theoretical platform Gormley separates himself to a large extent from his immediate contemporaries: in choosing this particular image as the means to these ends he in turn removes himself from the aegis of certain sculptors who, earlier in the century, grappled with similar ideas (Brancusi's project for a temple in India with its heightened feeling achieved by means of condensation, simplification and stillness in the elements is exemplary for Gormley).

The naked male, slim and lithe running or standing alone in an undifferentiated space or an unidentified milieu is a leitmotif of much recent art. A simplified cipher, rendered often in a deliberately crude or banal style, it does little more than allude to conditions or states of being: much can be omitted because the rules of the game have been so well rehearsed. Although many of Gormley's drawings have affinities with this genre, their primary function for him is that of ''fertile compost''. In them he tackles ideas and themes which can not be explored in sculpture although often suggestions better suited to three-dimensional realisation also arise. Interconnected in this way the two modes remain, however, distinct because the sculptures, irrespective of the subject, insist on their objectness, on the immutable fact that they are entities invading an actual space, mapping terrain. Since their physical existence is unquestionable, they make their initial impact as presences: only with scrutiny do they reveal their function. Always lifesize and always whole, they are neither mere signs nor recognisable individuals. If too schematic they risk losing something of the potency and vitality of animate images; if too specific they become portraits, taking on a character which threatens that focus on a state of being which is the artist's principal concern:

> I don't want the work to distract by suggesting a likeness or giving form to features. I want to make you aware of the whole. I want the work to deny the particular in itself so that it can be supplied by anyone who is looking at it.[6]

Thus, on the one hand Gormley eschews identifiable situations of the type that invite a description of the figure's behaviour (as occurs in the work of George Segal, for example, where modern dress and contemporary contexts are crucial indicators); on the other hand, he wishes to avoid engaging with emotion in an expressionist manner. Like Lembruck he often utilises the single figure in isolation but he never distorts the body in an anti-naturalistic manner for expressive effect. And though his is a realist style, Gormley is far removed from that late nineteenth century preoccupation, stemming from as well as reaching its apogee in Rodin, which treated the body as the physical mirror of the soul. In Rodin this resulted finally in fragmentation for greater intensity and eloquence; for others who retained the body intact, like Lembruck, it became almost impossible not to treat the hands and face as the foremost sources of emotional effect. Significantly, Gormley has both conserved the figure as an entity and avoided privileging these elements as the expressive foci. He achieves this by means of a variety of devices which constantly temper the illusionism, which make any understanding of the form inseparable from an awareness of its fabricated nature. For instance, fingers and toes

are fused into a single shape; the facial features being broadly handled and the skull generalised, it is the angle at which the head is carried in relation to the rest of the body which proves most telling. Recognition that this object is a container or sheath and not a surrogate human being is furthered by leaving the welds raw and unfilled, but also by the manner in which the joins in the casing constitute a grid similar to that on a geographer's globe. Not only do they rarely outline or emphasize the plastic quality of the form beneath but, by establishing an alternative frame of reference, they make evident the fact that the body exists in a gravitational matrix, that it inhabits the external world. Since this web is aligned with the major terrestrial axes, those deviations from it caused by certain unstable poses only serve to reinforce this connection. At times Gormley also cuts holes at strategic points. In addition to their symbolic function, they serve to dramatise the interior hollowness, to mediate between inner and outer space. Recently, in *Lift,* (ill. 26) the artist drilled the entire carapace full of holes; in lightening the actual material weight of the object he automatically invoked the abstract subject. The modelling of the forms also varies slightly from work to work: sometimes the surface inflections correspond fairly closely to the major planes of the model; elsewhere the casing is more generalised. Such decisions depend on various factors, including the legibility of the pose, the theme, and the desired viewing distance (squatting or crouching figures invite a closer surveillance). But Gormley never attempts to make an exact mould of his body. Indeed at times he recuts and reshapes limbs for practical reasons: for example; after he had broken his arm he was unable to straighten it fully for some time and so remade those sections taken from it in order to 'normalise' the figure. Idiosyncratic information about the figure is anathema to him, a distraction from the more universal issues at stake. Detail is sacrificed in order to hone in for greater intensity but distilling does not imply refining: the actual finish is workmanlike not elegant. For Gormley's work is representational without being illustrative: true to experience and feeling as distinct from actual observation.

Gormley employs the body as an emblem rather than as a surrogate agent which demonstrates poses and attitudes for the observer to read, as in the case of Lembruck, or as a form to engage with sensuously as in Rodin. Gormley seeks to evoke a state of being; feelings are neither illustrated in the sculpture as occurs in much expressionist work nor are they culled from the viewer in response to a theatrical presentation as Bernini does, preeminently. Because Gormley's forms are generic they are seen as representative; because they are not mimetic they

are seen as emblems; because they are static they are contemplated rather than interpreted in narrative terms.

This mode of using the body as emblem is less prevalent in western sculpture than in Indian sculpture where the image of the body often acts as a trigger or starting point for evoking a state of mind. In the West it is icons rather than statuary which possibly provide the nearest equivalent. An icon of the Virgin is not a representation of a particular woman but an image inhabited by her spirit: not a person but a vehicle for spiritual contact and communion, and as such it functions very differently from most occidental art that is representational:

> I want the work to function as a vehicle. Sculpture, for me, uses the physical means to talk about the spirit, weight to talk about weightlessness, light to refer to darkness – a visual means to refer to things which cannot be seen.[7]

But whereas for the western believer the icon is an intermediary through which the faithful approach the supernatural and thereby transcend the earthly and bodily, this is frequently not the case in Eastern thought where the identity and interpenetration of spirit and matter are posited; spiritual and physical are located in the same form and it is only the acuity of the observer which makes the spiritual manifest. For Gormley, sculpture is a perfect artform for such concerns: in the very recognition of its obdurate physicality access to disembodied states is made possible:

> The spirit is wholly incarnate in the image of man and I seek to express this through the language of my own body.[8]

> The musician in India finds a model audience – technically critical, but somewhat indifferent to voice production. The Indian audience listens rather to the song than to the singing of the song: those who are musical, perfect the rendering of the song by the force of their own imagination and emotion. Under these conditions the actual music is better heard than where the sensuous perfection of the voice is made a *sine qua non*.[9]

Coomaraswamy, one of Gormley's favourite writers on art, indicates certain crucial factors in his aesthetic: the participation of the viewer in effecting the final resolution; the involvement with simple yet major issues not with virtuosity and self-expression; skill valued as a means not

an end, just as beauty and formal harmony are not sought in themselves but as a by-product of ideas fully realised. Gormley chooses what might be called rudimentary activities – external sensory experiences such as seeing, listening and shitting; internal experiences such as thought and dreaming – and basic categories – animal, mineral and vegetable – as points of departure. This desire to deal with elementary categories or fundamental experiences might have involved the artist in some kind of primitivising, in borrowing from so-called primitive arts or in a search for archetypes, believed to be most directly expressive of basic states. For linkages between the primitive, the archetypal and the essential have subtended much twentieth century art. Yet Gormley has abjured such references, recognising that those connotations which do adhere to primitive ideographs and totemic imagery have been largely attributed to them by the cultures which appropriated them. Acknowledging the dubious nature of this relationship and the breakdown in a common language for public sculpture in the twentieth century, led Gormley to concentrate on personal experience of an ordinary kind, taking as his central image what is most convenient and adaptable – his own body. By eliminating distinguishing marks or features, by reducing it to a type – if not to the archetypal – he avoids autobiography.

Gormley's concerns are ultimately with man's well-being but it is, he argues, by means of a heightened spiritual awareness instead of through psychological and social transformation (through changes in the material conditions of life) that greater self-realisation will ensue. Art can, he asserts, have a healing function; through catharsis it can intimate some notion of release or escape. This might be deemed a religious philosophy rather than a humanist one – on account of its sources as much as it precepts. Its roots lie in the Catholicism of Gormley's childhood and in Buddhism with which he was most intensely involved during the three years that he spent in India; both systems of thought continue to shape his thinking. These, or similar philosophies, have engaged many artists this century but what is striking about Gormley is his ability to steer clear of mysticism; that is, to realise his ideas freshly and intensely with very familiar forms. Gormley sees his art as polemical and engaged: socially conscious in a fundamentalist and not a reductivist sense, it avoids both escapism and naive idealism:

> The fact that man is daily better equipped to destroy himself and the world and
> increasingly less in control of his actions is very much in my mind. I am aware of the

fragility of our world, of the difficulty people have living together. I think in some way my work faces up to these things… *Night* is where the hope lies. *Night* suggests there is a basic analogy between the most basic human experiences and the great forces of nature – that connection is important to me. By what is man to regulate his actions? Firstly through communion with his fellow beings and secondly through communion with the natural world about him. For me the way of understanding is through the latter first. The wilderness is a good tool. *Night* identifies a human space in space: there is a relationship between the infinity of space within the body and the infinity of the sky.[10]

Although the central motif in Gormley's art is currently the human body it has appeared at intervals, albeit in different guises and contexts, throughout his oeuvre. Among the earliest pieces of sculpture he made were a series executed upon his return from India in 1973 and prior to his going to artschool (ills. 1-3). In these a figure lay on the ground, sometimes huddled almost in a foetal position, sometimes casually stretched out as if in sleep but always completely enveloped in a sheet. The sheet was then coated with plaster so that the final form, a free standing white tent, revealed at salient points the pressure or impression of the body beneath: a protruding knee, elbow or shoulder. The space contained within such a flimsy covering was all that the body seemed to possess as if it could defend only what it displaced. The vulnerability, the defencelessness that sleep inevitably engenders could not be mitigated by this frail covering, nor by the drawing together of the limbs and the shrouding of the interstices between to create a cocoon, a nomad's shelter. Although these works have never been exhibited certain concepts explored here have proved seminal, and recur in much of his subsequent work.

The notion of a threshold or boundary that both contains and indentifies the place of existence is embodied in other works where the figure is also suggested only in absence. *Room* (ill. 9) is demarcated by ropes made from a set of clothes shredded and wound around a space to create a boundary. In *Bed* (ill. 8) the absent form of the recumbent figure is indicated by the hollows eaten out of the tomblike rectangular block of bread: in *Mothers Pride* (ill. 16) a silhouetted figure has been chewed out of a wall made of the same foodstuff. Both point to the way in which man consumes to survive and survives by destroying. This and related

themes, such as the debate between using and consuming, presence and absence, natural and manmade objects, have been treated in various ways in Gormley's work. They stem from his preoccupation with the nature of the world, and man's role in it, indicated through his relationship with objects as well as with space and site. The condition of the natural world, for example, is the point of departure for *Three Bodies* (ill. 10), a triad of earth-filled lead cases made around a shark, a pumpkin and a rock.

> I wanted to bring together the three realms of matter: something from each of the animal, plant and mineral worlds. The shapes were important – simple and clear... Everything on this planet is earth above ground therefore everything is connected. I have tried to express this in the work by unifying the surface, the time and the physical interior... My first duty is to identify for myself what the world is: that is *Three Bodies*.[11]

Broadly speaking, prior to 1980 Gormley's work dealt with knowledge – he talks of each work being a kind of proposition or debate physically realised – as he attempted to understand the world around him. Since then he has dealt with experience, with what he feels it is like to be a human being. To the degree that this later work is subjective, the previous work was objective. Neither metaphor nor agent, the artist's body is both a tool and a material for the investigation of two preeminent themes: man in physical space, and man in relation to his inner space – and the relationship between his inner world and his physical being. These concerns, eclipsing others possibly only temporarily, have arisen in part from Gormley's feeling that objects can no longer fully express what he wants to say, that the body is a more direct and effective medium:

> objects are good for understanding the world
> because they inhabit the world
> body is good for making experience visible
> because I inhabit it.[12]

And just as he has concentrated increasingly on a single motif, so he has confined himself almost exclusively to a single material: lead.

> Lead brings silence and stillness. It is a wonderful material – it is so inert, so dense, its greyness combines all colours, its quality as an insulator is important. It protects against all forms of radiation – and that is part of its power. It renders things inert but because of its nature that inertia is potent: like a seed.[13]

Gormley's earlier works, especially those that dealt with oppositions between the natural and the cultural and which sought to mediate between the two arenas, like *Fruits of the Earth* (ill. 7), developed in part from his interest in issues which could be said to belong to the field of anthropology. What made these sculptures eloquent was the fact that the initial ideas were so fully internalised that they did not require a theoretical apologia. The success with which Gormley was able to interpret such ideas depended in part on his tendency to multiply allusions, generating a truly poetic set of associations, rather than proceeding by means of analytical, rational dissection. Through the use of verbal and visual puns, conceits and conundrums, homonyms and metonomy, Gormley imbued his works with a complexity that is revealing instead of confusing.14

Recently, the bases of his thinking have shifted, leading to a stronger engagement with writers like Coomaraswamy, Teilhard de Chardin and Blake. They have reinforced his belief that art has a crucial function to fulfill – ''not only to heal but to prophesy'' – and that it must direct itself unequivocally and insistently in the most accessible manner to this end (without, however resorting to illustration or didacticism). Nonetheless, the changing emphasis in his work should not be overstated; it is one of degree, not of kind. More than a residue of his former tendency to conflate associations can be found, for example, in *Still Falling*, (ill. 22), a male figure carved this summer into the face of a quarry at Portland. The body is literally transfixed though this is not the impression it makes. With legs and arms vertically aligned, and the head the most legible section of the silhouette, the figure seems to be responding to gravity – not simply at its mercy. It appears to have adapted gracefully to its novel circumstances rather than fighting them, and in so doing gains new powers such that it floats without anxiety or tension. *Still Falling* suggests that even man's most fundamental aspects can be transformed by harmonising with the situations in which he finds himself, however unprecedented. In the various examples of *Man Rock* (ills. 23&24), in each of which the silhouette of a figure is inscribed on the surface of a boulder, the interdependence of man and nature are once again vividly expressed, as the image protectively cradles the very form which has given substance to it. The title, always an important component in Gormley's work, enhances such allusions with its echo of 'bedrock', the solid stratum beneath layers of superficial formation.15

By contrast, the lead covered figures seem more self-evident. The artist feels that the greater eloquence and economy in statement can be attributed to a concentration on issues rather than on formal niceties, but his growing experience with both the material and with the motif surely also contributes to the new sense of authority. This is evident in the choice of gesture in *Address* (ill. 41). In principle, the challenging posture should arouse speculation as to the situation that provoked it: questions as to whether the figure is aggressor or respondent; whether playful or insolent; whether a coarse parody of the dignity implicit in statuary or a covert homage to Degas' *Young Spartans...* In fact none of this preoccupies the spectator for long. *Address* is not a riddle. The incidental and circumstantial drop away as the observer ponders on the feelings that the figure evokes, in place of considering the contexts in which such actions arise. An act of identification takes place, for Gormley avoids an active confrontation between spectator and sculpture-as-other of the kind found in say Giacometti's *Woman for Venice VIII, 1956.* Instead he elicits a transference of allegiance to the figure itself. The mental state is apprehended by means of intuition rather than generalisation from previous experience; and in this respect it could be argued that the state of being is rendered in phenomenological terms.[16] The sculpture depicts neither the essence of the concept 'address' nor is simply an instance, an example, of it.

In certain other respects *Address* is perhaps the most daring of Gormley's works to date. it comes closest to establishing a dialogue between observer and object, yet characteristically leaves the object-in-itself as the actual point of departure. In different ways *Three Places* (ill. 25) also eliminates any interchange of this sort. However, here the danger is that some kind of anecdotal or narrative relationship might be set up amongst the components. The manner in which they are disposed is crucial in that it prevents an interpretation that sees the three figures as simply different moments in a single endeavour: an attempt to transcend the purely terrestrial. By refuting a sequential connection Gormley is able to concentrate on the different stages in an abstract condition – resurrection. These are separate states of being, not moments of becoming.

Significantly, when realising certain states of being which are active, which engage with the external world, such as speaking or walking, Gormley does not always adopt the most graphic posture. *Pass* (ill. 34) which is conceived in terms of walking – the figure takes a step, hands by

the side of the body, head raised – presents an interesting comparison with precedents in Rodin and Giacometti. Gormley's figure has a strong sense of motion in the torso yet somehow the form is arrested, perhaps partly on account of the angle of the head. The motion is not instantaneous, a frozen moment in time as Rodin desired; nor is it distant in the manner of Giacometti's figures which are perceived as if at a considerable remove. It is more akin to the impression given by a person skating, where the body seems to move without weight, where certain physical limitations have been temporarily suspended. If *Plumb* (ill. 36) is appositely withdrawn in an enclosed position, the crouching symmetrical *Cast* (ill. 35), hands cupped to the mouth, betrays little, which stresses the notion of emission in its formal configuration.

> The extraordinary thing is on the one hand the consistency of human feeling and, on the
> other the infinite variety of ways in which it is expressed.[17]

Actions and feelings, though familiar, cannot be formulaic. Gormley appreciates that the subjects of *Three Calls* (ill. 33): thought, speech and action are mundane but does not make them banal. It is however only with the conjunction of the three figures, which occurs without anecdotal interchange, that the different states fully crystallise and a stillness conducive to contemplation is established. The question which could arise with the multi-figure works, whether it is the same body three times over or whether three different beings (and if the latter what distinguishes one from the other), becomes irrelevant when naturalism and narrative are so consistently contradicted. Gormley's aim, in these multi-figure works is ambitiously inclusive and there is a strong underlying investigative structure linking them. Cumulatively, they encompass a vast range of experience: *Three Ways* (ill. 11) deals with basic bodily functions; *Land, Sea and Air II* (ill. 17) with perceptual functions; *Three Calls* (ill. 33) with different means of communication and *Three Places* (ill. 25) with functions of consciousness. In the finest, such as *Land, Sea and Air II,* Gormley creates a space that is immeasurable yet highly charged. The absence of a direct engagement with any component means that though physically charged the work is in some way set apart, at a remove, and gradually an awareness of the real, habitable space that the figures enclose gives way to intimations of an unenterable, purely mental, space: available to the mind alone, it becomes a space of meditation.

> The element of time that involves the spectator concerns reflection. The work presents a
> point of stasis between origin and becoming. The spectator completes and in a sense

becomes the work, by a reflective action of relinking the work with the world.[18]

The raison d'être for this concern to establish a sense of stillness within even the most vigorously active sculptures is well expressed in Coomaraswamy's words:

> Over against the world of change and separation there is a timeless and spaceless Peace
> which is the source and goal of all our being.[19]

Yet discussing the figure sculptures as a group can be misleading in that the role, if not the basic form, of the body alters from work to work:

> *Land Sea and Air II* uses the body as an agency to experience the elements. So, for instance, the standing figure has its eyes open: holes that connect from the outside to the inner space. It is a vessel for the experience of the horizon... (by contrast) *Box* was inspired by a figure in Blake's copperplates for *Jerusalem*. It is a hunched figure with its head between its knees; the body becomes like a capsule, it is very internalised; the attitude and the feeling of the figure is inward turning – an external sign of a human being coming to terms with the void within.[20]

Transference from a perception of the action to an engagement with the inner state is enhanced by the fact that very often the poses themselves are synthetic. In *Address* (ill. 41), for example, the arms unexpectedly repose within the body rather than extending the challenge outwards; in *Untitled* (Diving Figure) (ill. 39) though the arms are raised, the body as a whole is not poised to spring. The holes too contribute to the stress on the inner/outer connection. In *Three Ways,* (ill. 11) for instance, they are not only located at the vertical apex of each figure but their strategic positioning, at mouth, anus and penis, alludes to the requisite activities without necessitating more explicit description. Symmetrical, regularised and lucid, on a formal level these poses approximate to a line, pyramid and sphere. This reinforcing of allusions to the fundamental and universal through formal, symbolic and representational means is characteristic of Gormley's language at its richest.

It is unfashionable to be openly seeking ends which are more spiritual than secular in their metaphysics; it is unfashionable to discount to such a degree one's immediate cultural heritage – but Gormley is indifferent to questions of fashion. His recent work bears telling witness both to a resilient confidence and hard-won convictions.

LYNNE COOKE

All statements are by the artist unless otherwise indicated

1. *Objects and Sculpture,* Arnolfini/ICI, 1981, p.18

2. Thomas Carlyle, *Sartor Resartus,* quoted by the artist in a letter to the author, Jan. 1984.

3. The sculpture of Baselitz, Paladino and John Ahearn in different ways might be said to belong to the first category, whereas the work of Barbara Kruger, Cindy Sherman and Hans Haacke, for example, falls into the second. For further discussion of these issues see Hal Foster, "New York art: seven types of ambiguity" in *Brand New York,* ICA 1982; Douglas Crimp, "Pictures", *October,* Spring 1979, and Carig Owens, "The Allegorical Impulse; Towards a Theory of Post-Modernism", *October,* Summer 1980

4. Conversation with Paul Kopecek, *Aspects,* No. 25, Winter 1983-84, n.p.

5. ibid

6. ibid

7. ibid

8. marginal note made in Ananda Coomaraswamy, *The Dance of Shiva* (Bombay, 1948) p.100

9. Coomaraswamy, p.103

10. from an unpublished conversation with Vicken Parsons, Nov. 1983, n.p.

11. ibid

12. letter to the author, op. cit.

13. Unpublished conversation, op. cit.

14. Gormley tends to reject the use of metaphor on account of its open-ended references, preferring conceits, puns etc. which "wrap themselves up like a syllogism", reinforcing thereby the connectedness of the allusions, as is evident in both *Full Bowl* and *End Product.*

15. "The titles are as much part of the work as finding the material. The process towards certainty is very physical. There is a journey that the work is making from the general to the particular, from the unnamed to the named. This is a physical journey towards recognition which is expressed in the name" *(Objects and Sculpture,* op. cit., p.18). With the shift in Gormley's work from the object to the figure, from knowledge to experience, titling has become less significant.

16. This is not necessarily the term that the artist would apply. Compare, for example, Coomaraswamy (op. cit., pIII) ''This Indian music is essentially impersonal: it reflects an emotion and an experience which are deeper and wider and older than the emotion or wisdom of any single individual... it is in the deepest sense of the words all-human.''

17. *Aspects,* op. cit.

18. *Objects and Sculpture,* op. cit., p.18

19. Coomaraswamy, op. cit., p.103

20. *Aspects,* op. cit.

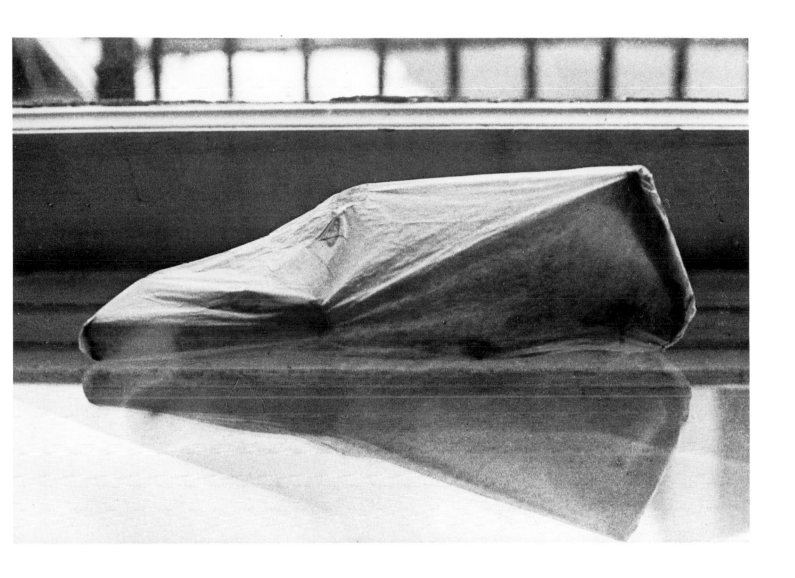

1 Sleeping Place

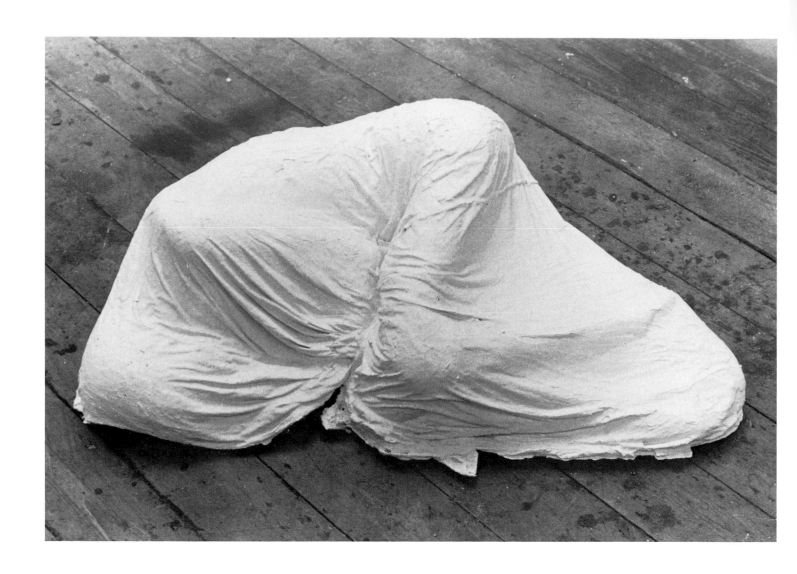

2 Sleeping Place

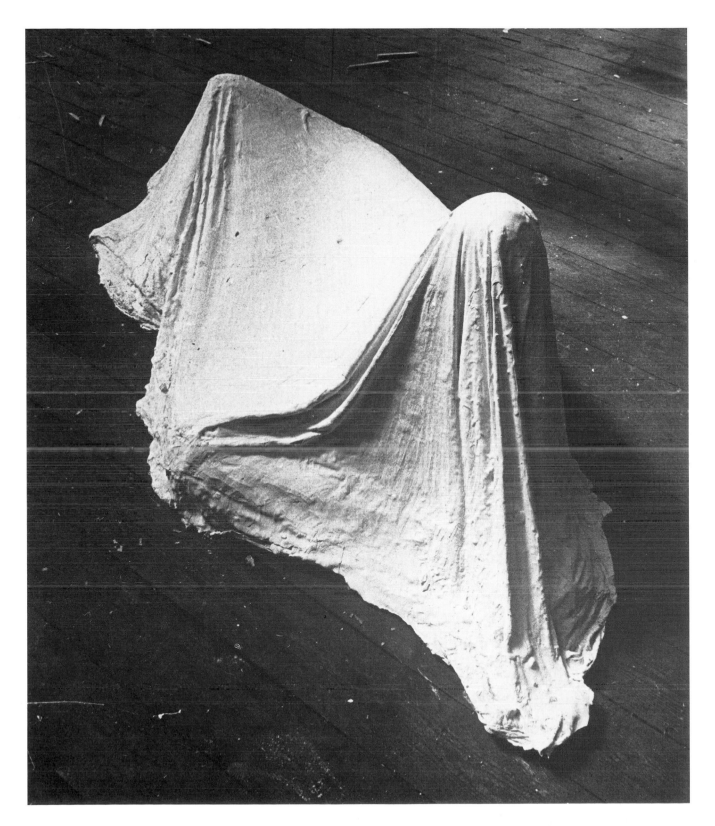

3 Sleeping Place

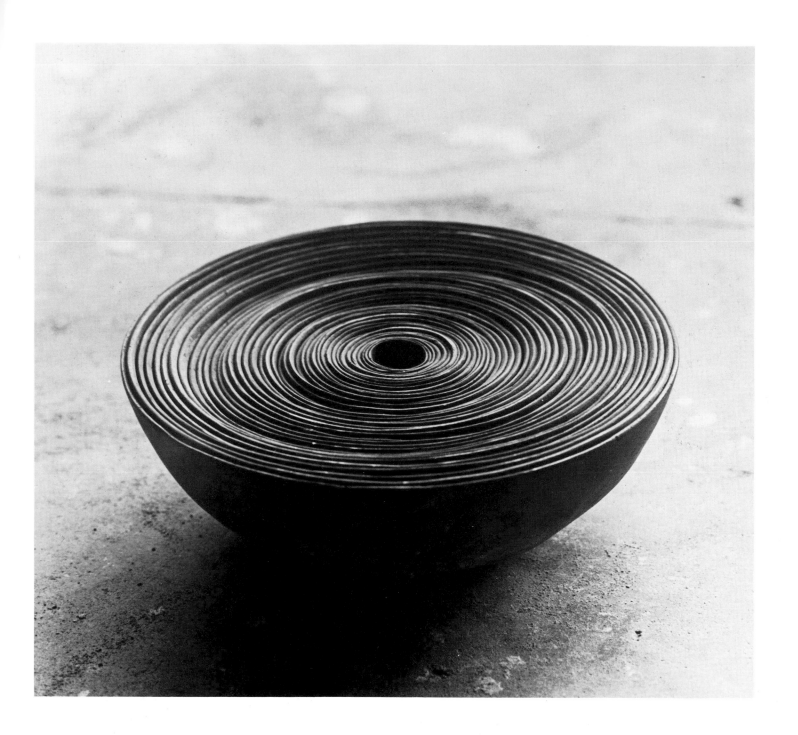

4 Full Bowl

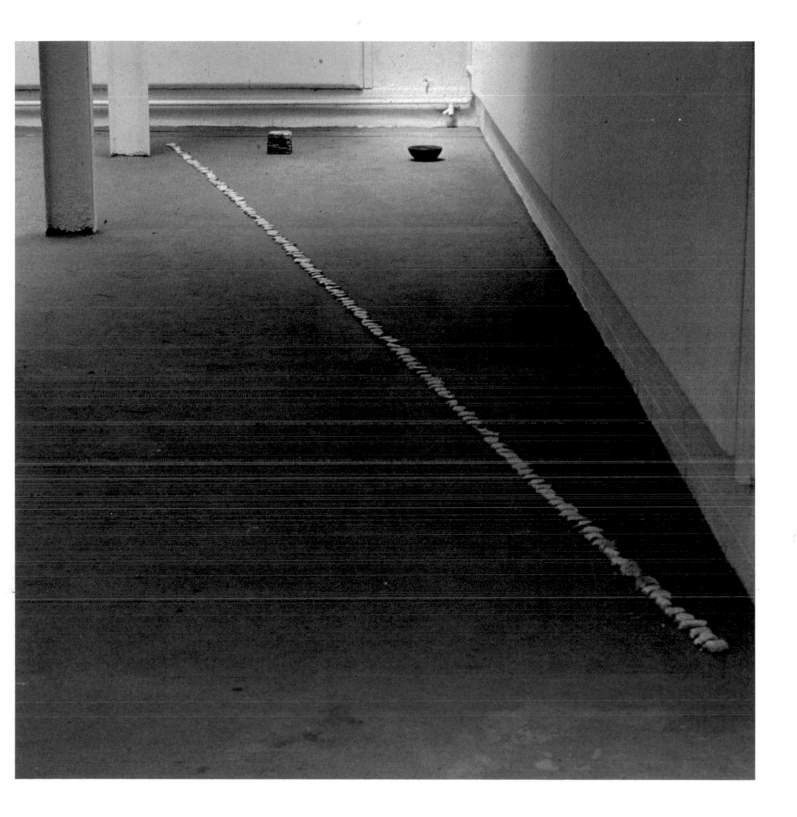

5 Breadline

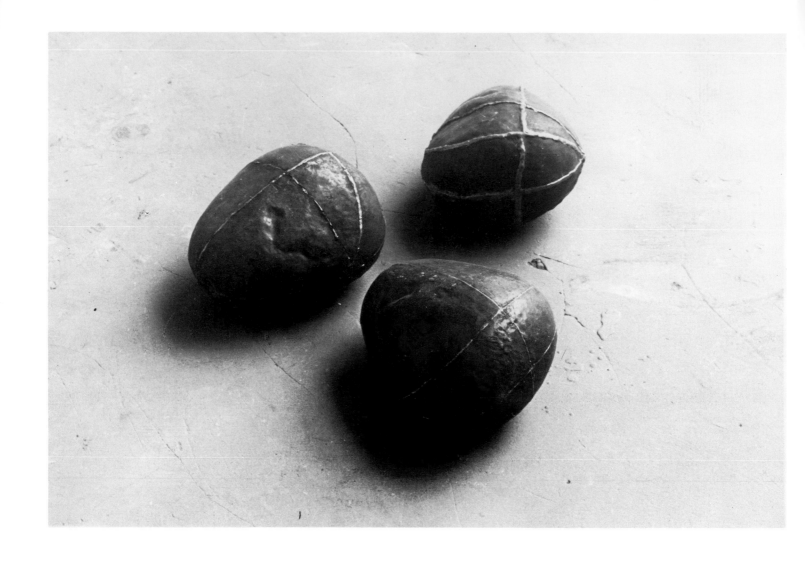

6 Land, Sea and Air I

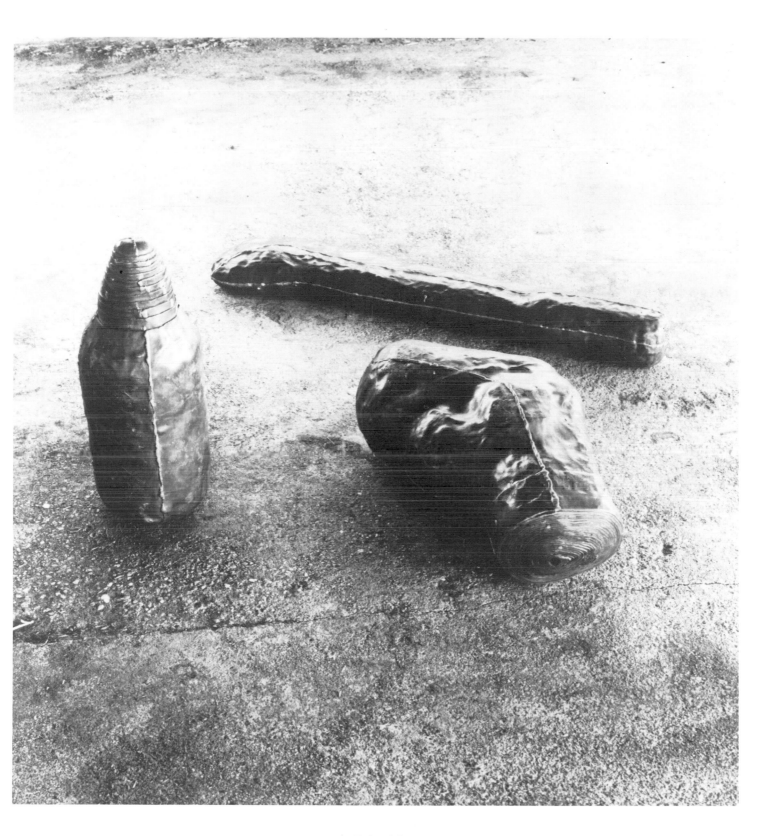

7 Fruits of the Earth

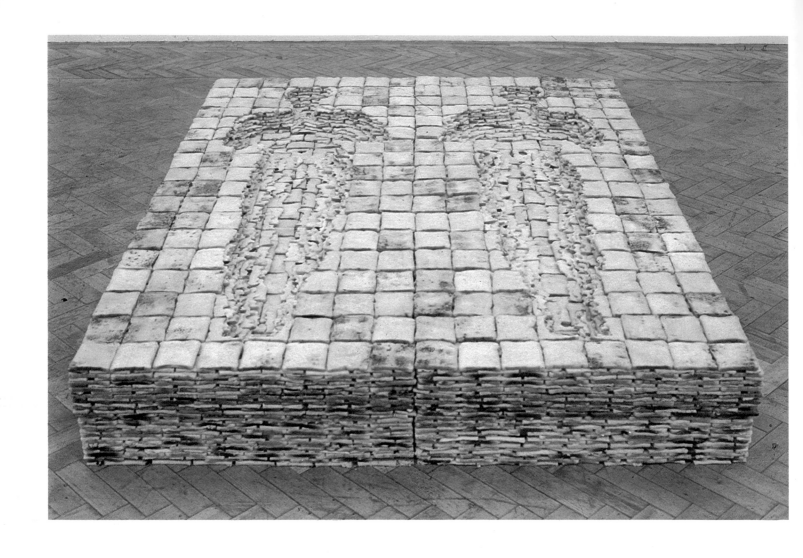

8 Bed

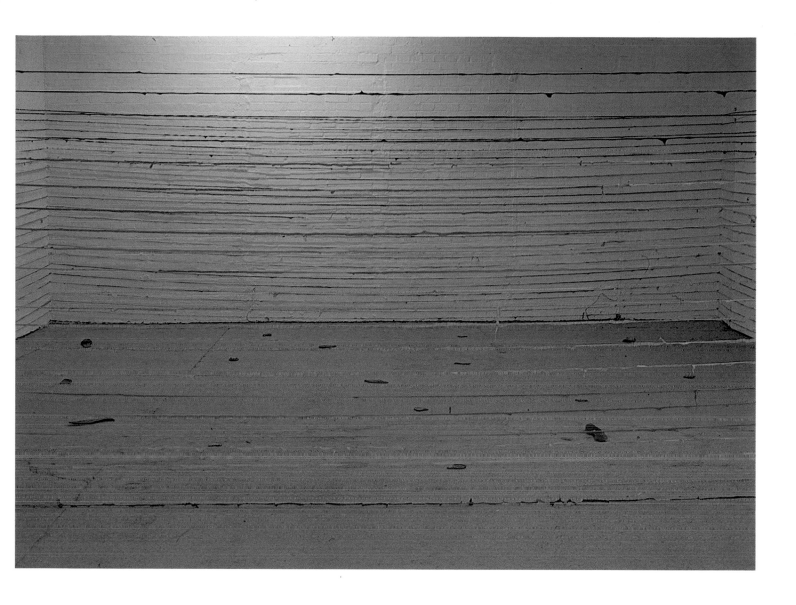

9 Room

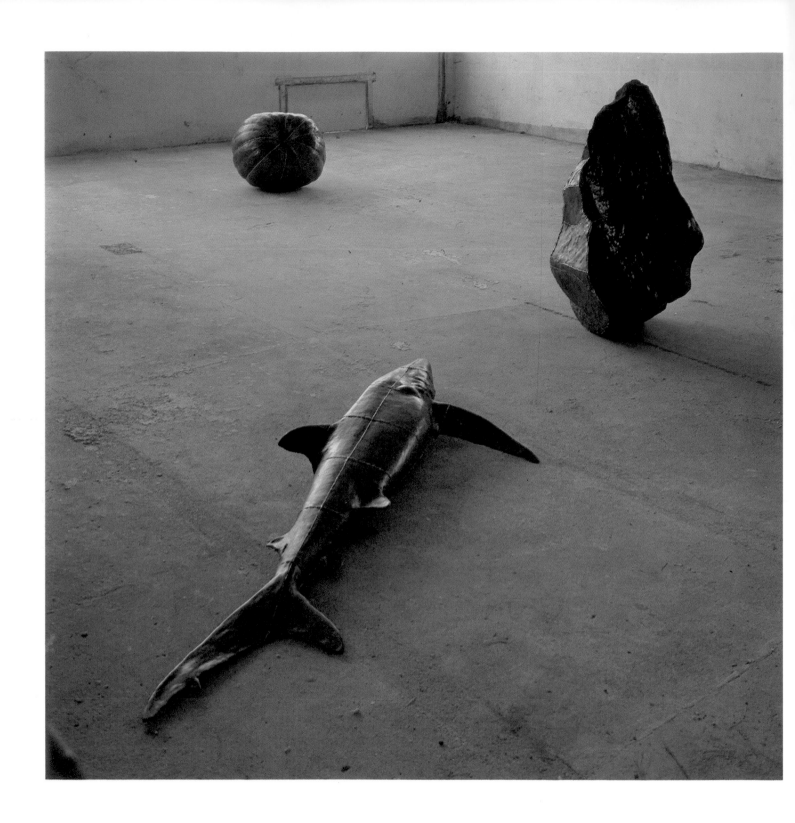

10 Three Bodies

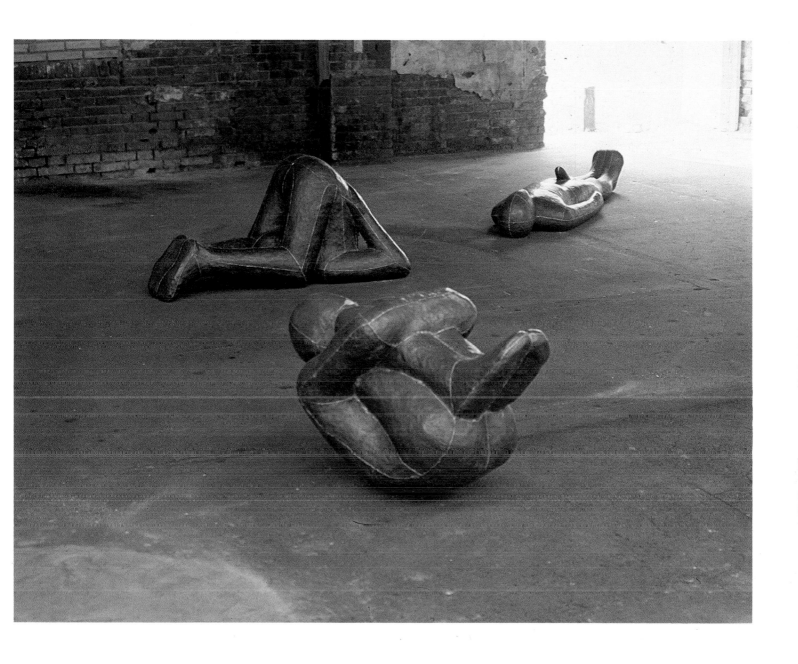

11 Three Ways: Mould, Hole and Passage

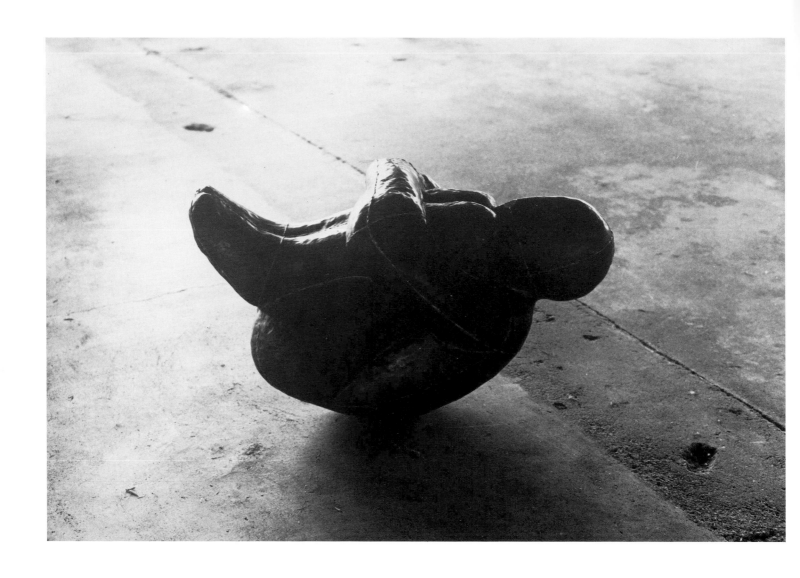

12 Mould

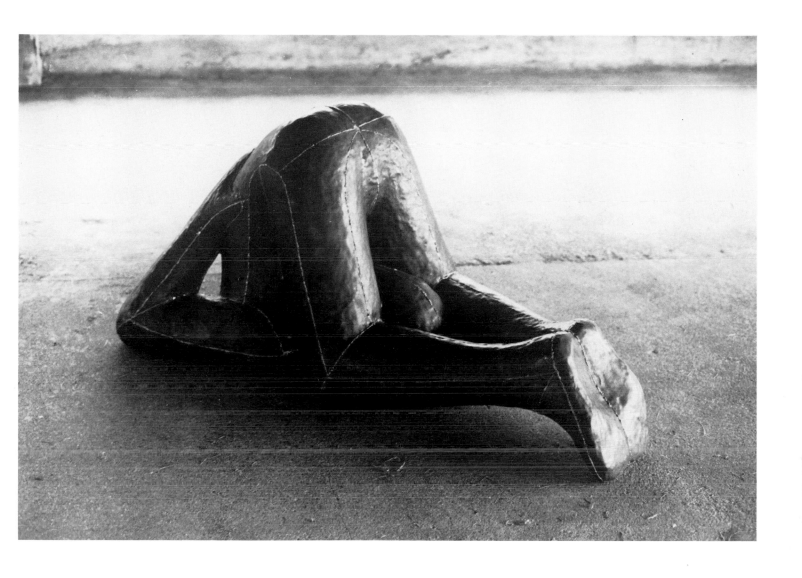

13 Passage

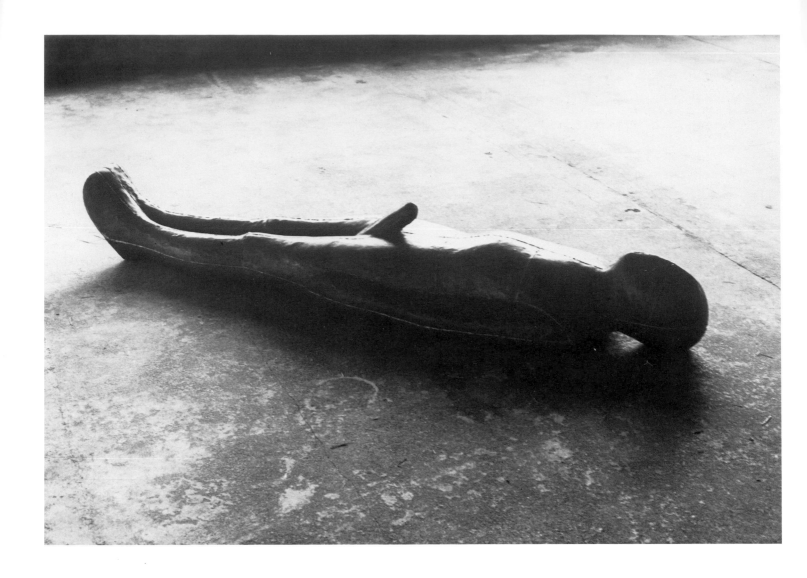

14 Hole

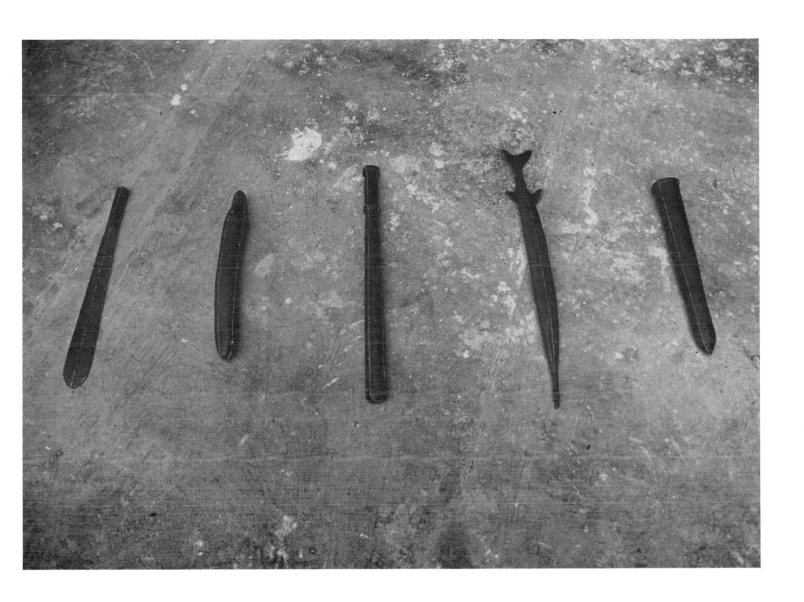

15 Five Fishes

16 Mothers Pride

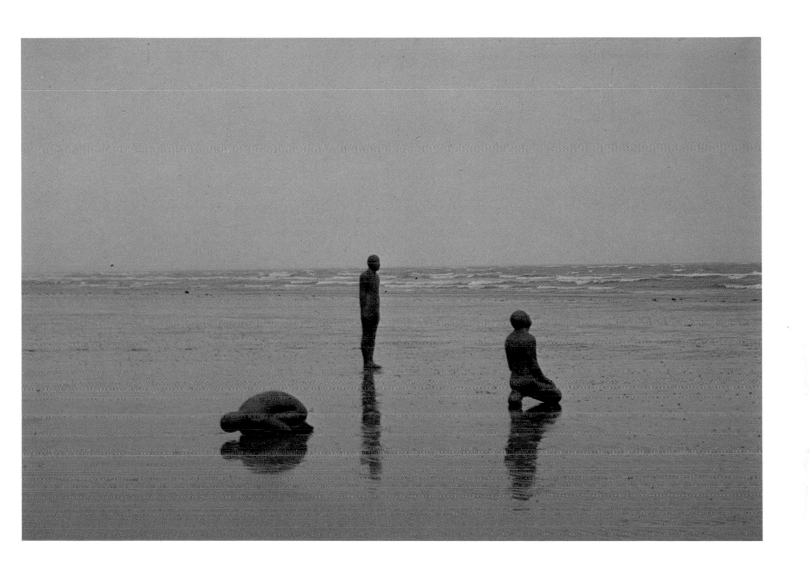

17 Land, Sea and Air II

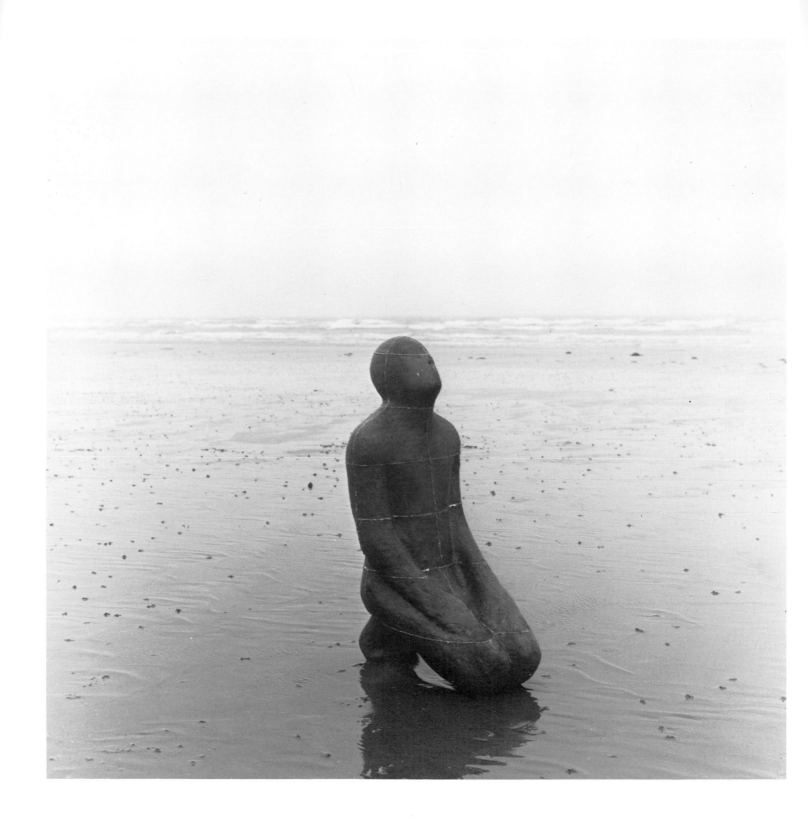

18 Land

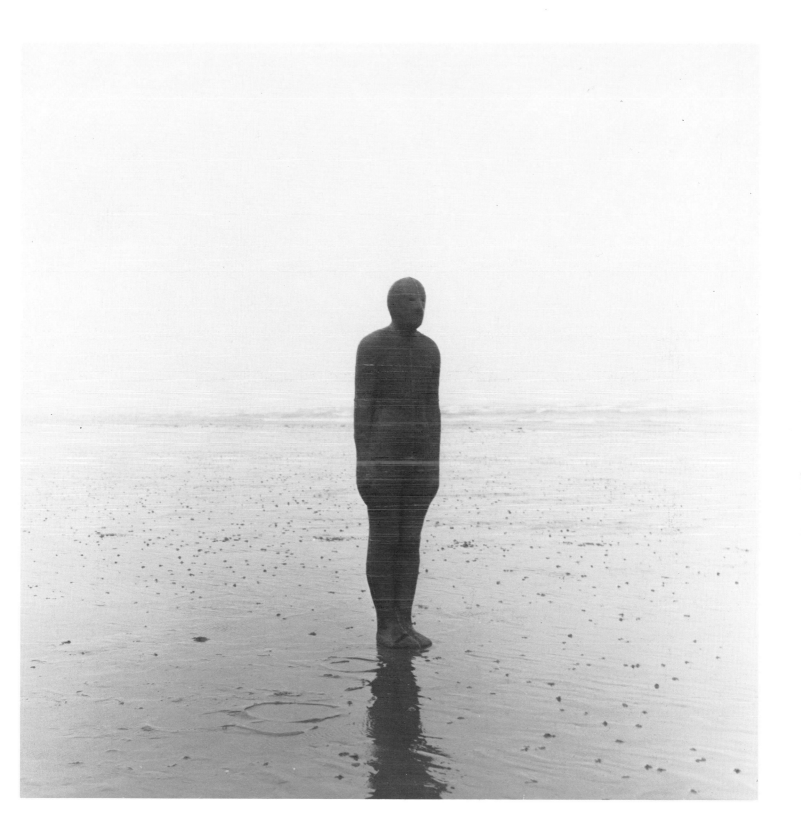

19 Sea

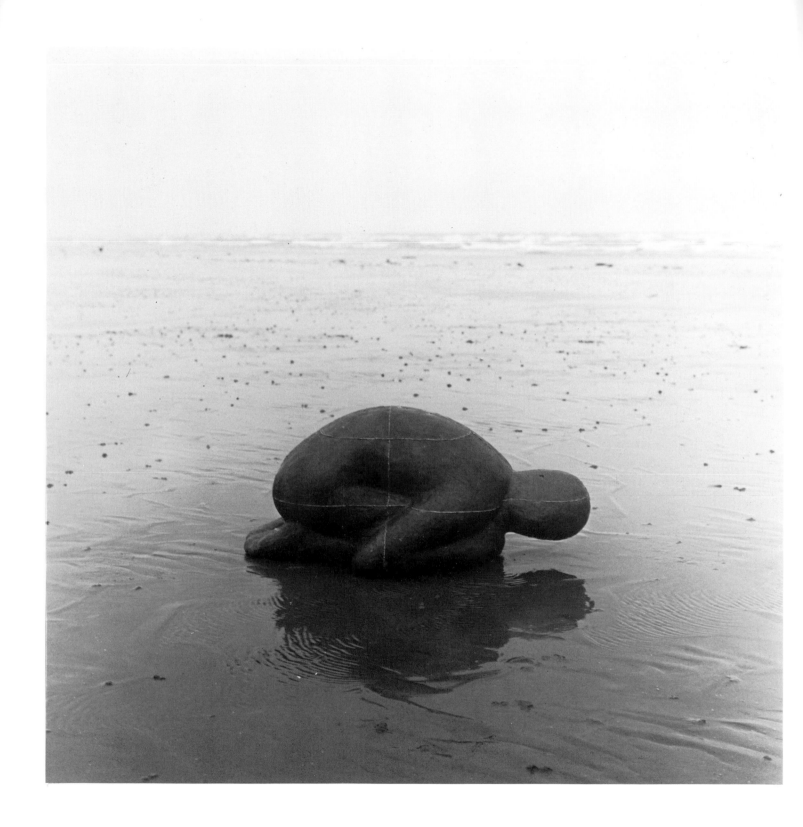

20 Air

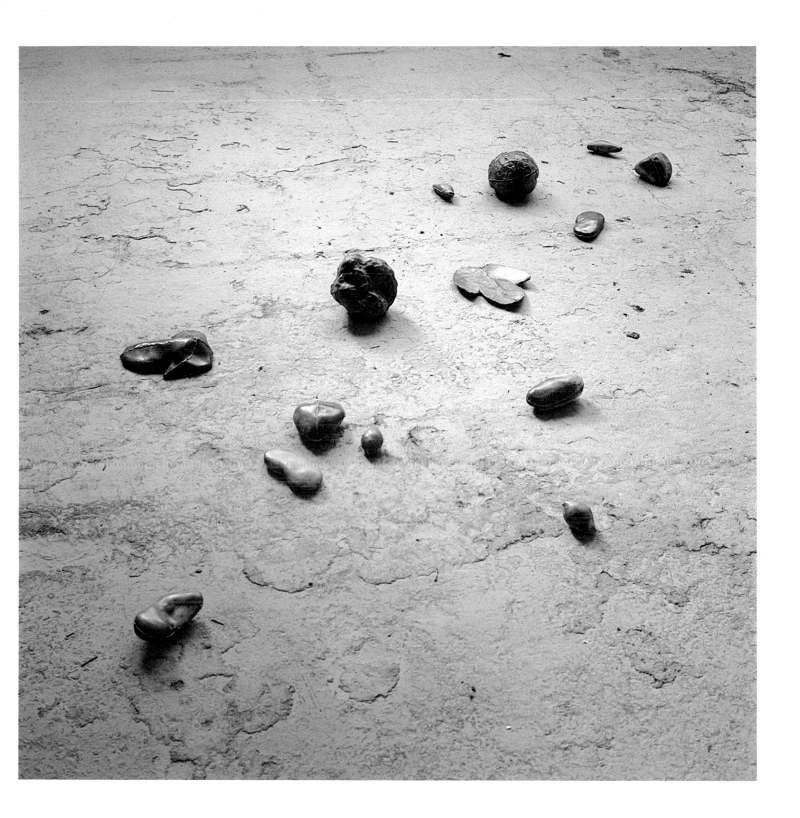

21 Islands

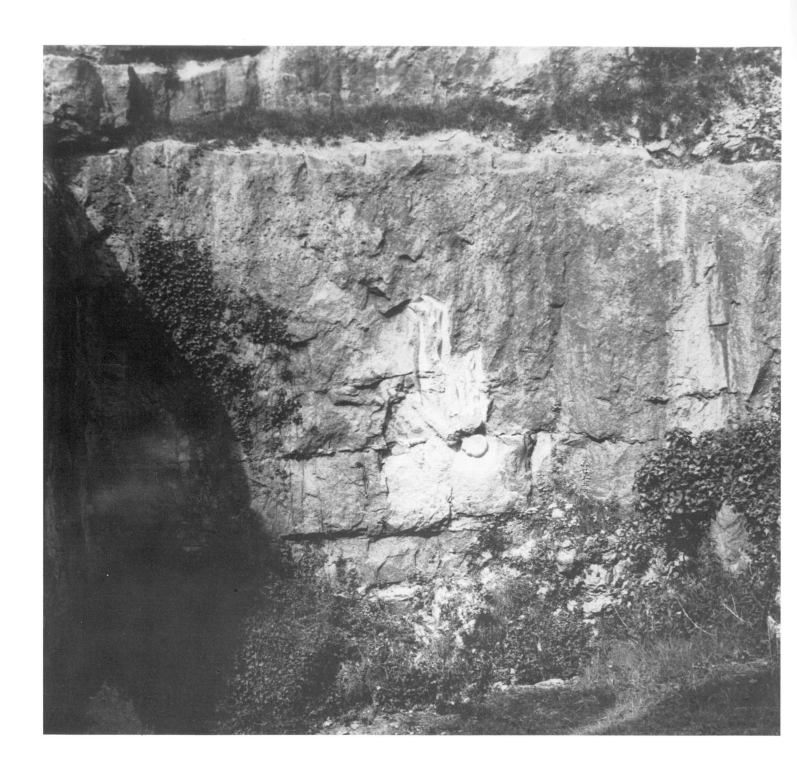

22 Still Falling

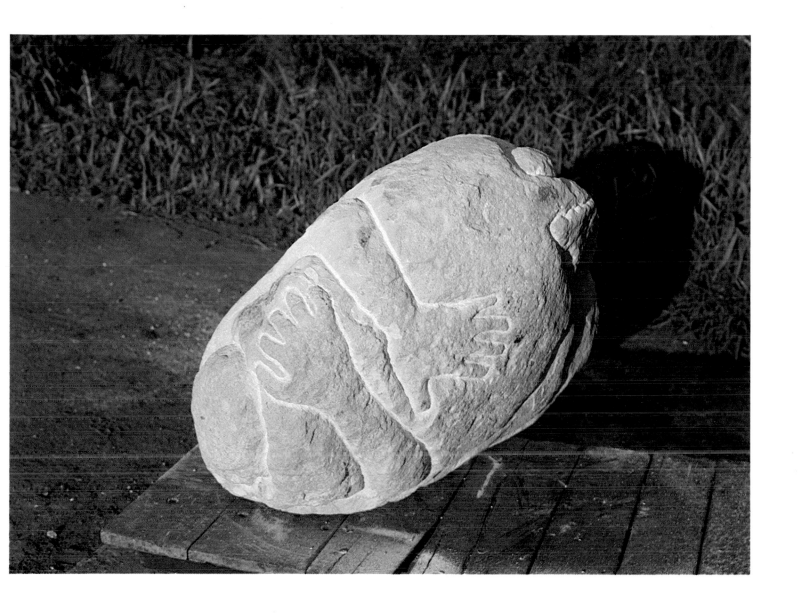

23 Man: Rock

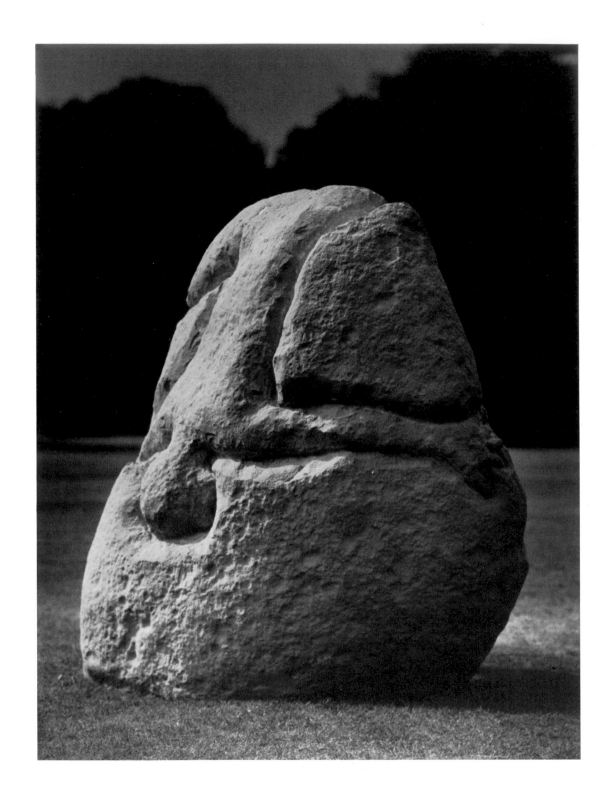

24 Man: Rock

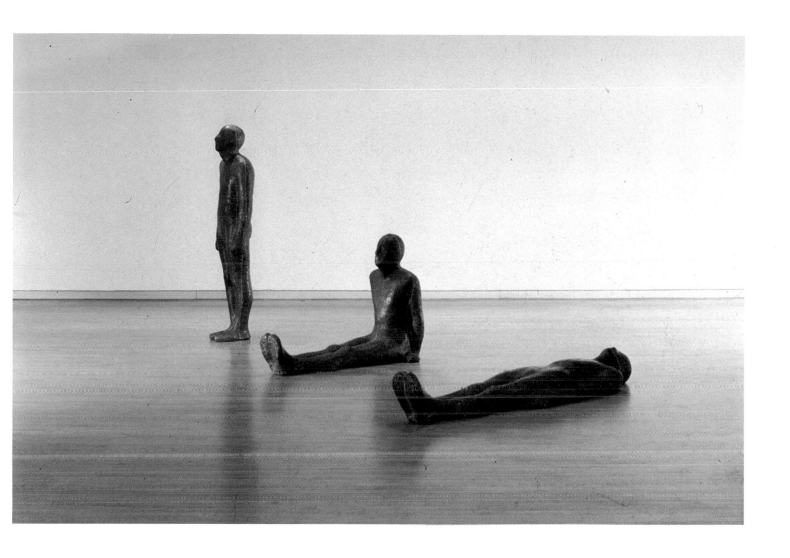

25 Three Places

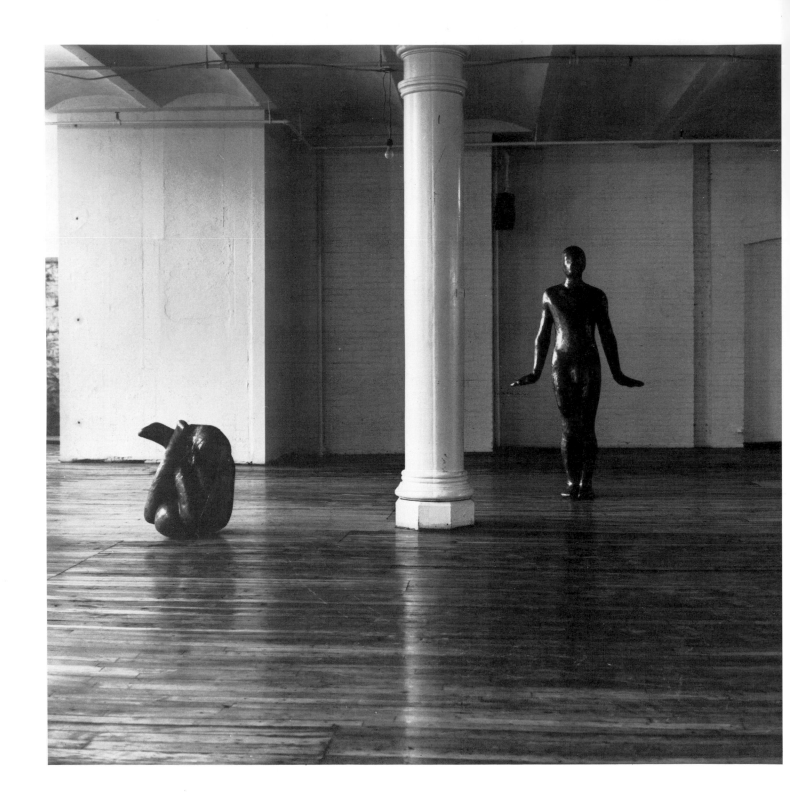

26 Lift and Fall

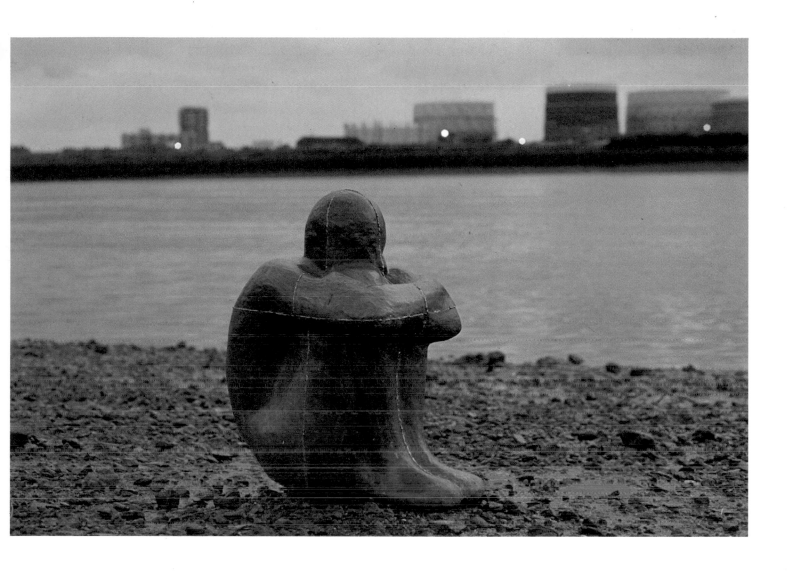

27 Night

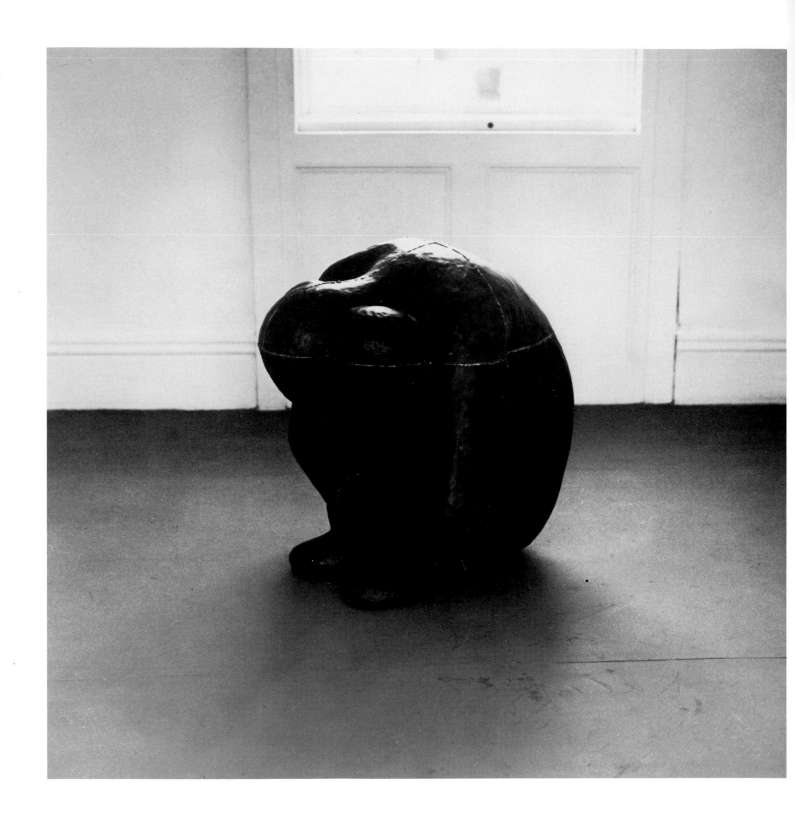

28 Box

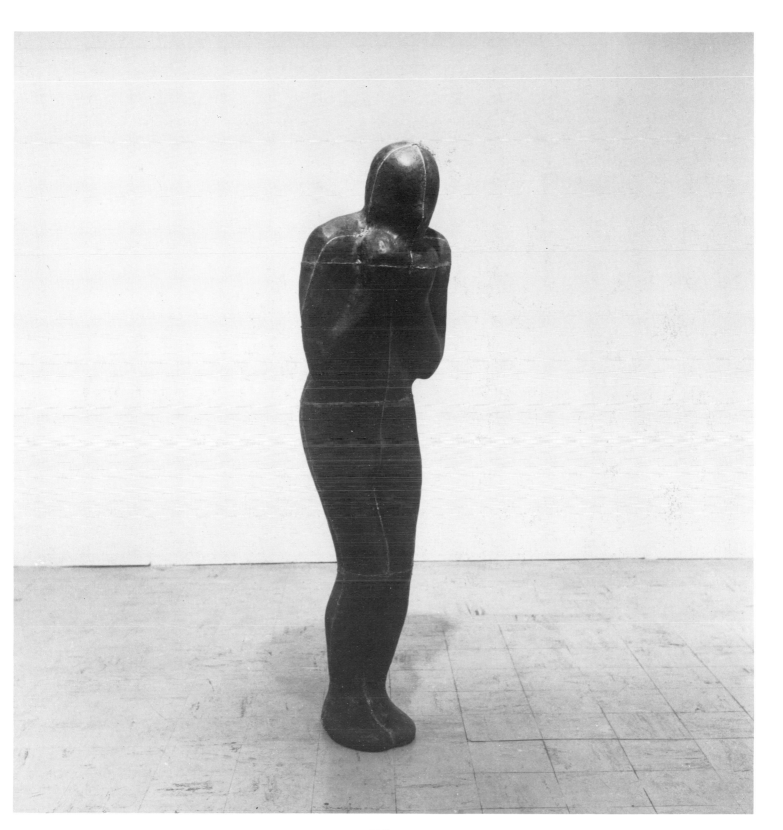

29 Vent

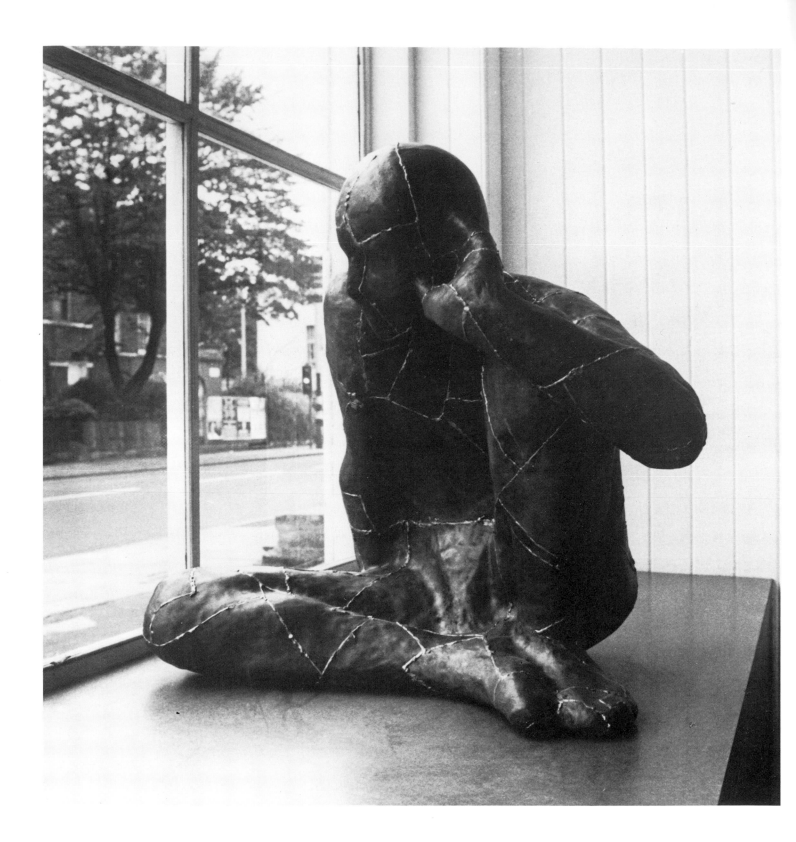

30 Untitled (Listening Figure)

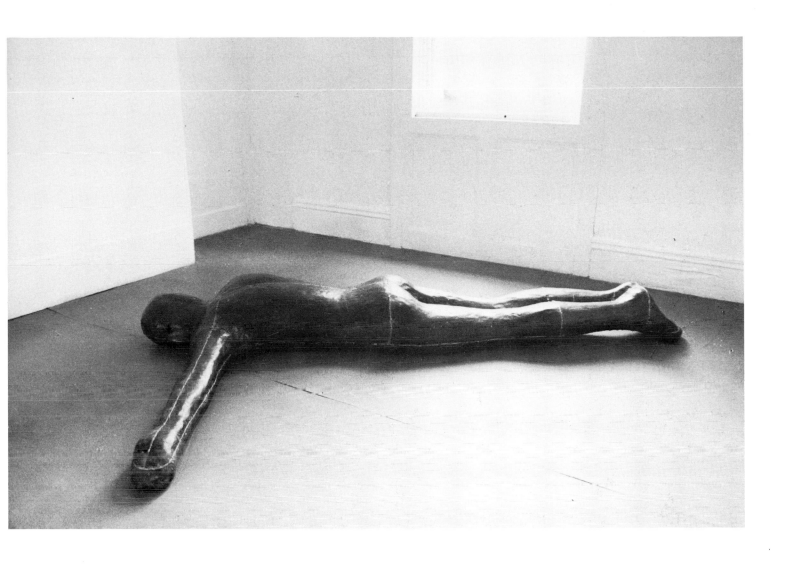

31 Desert (for Walter)

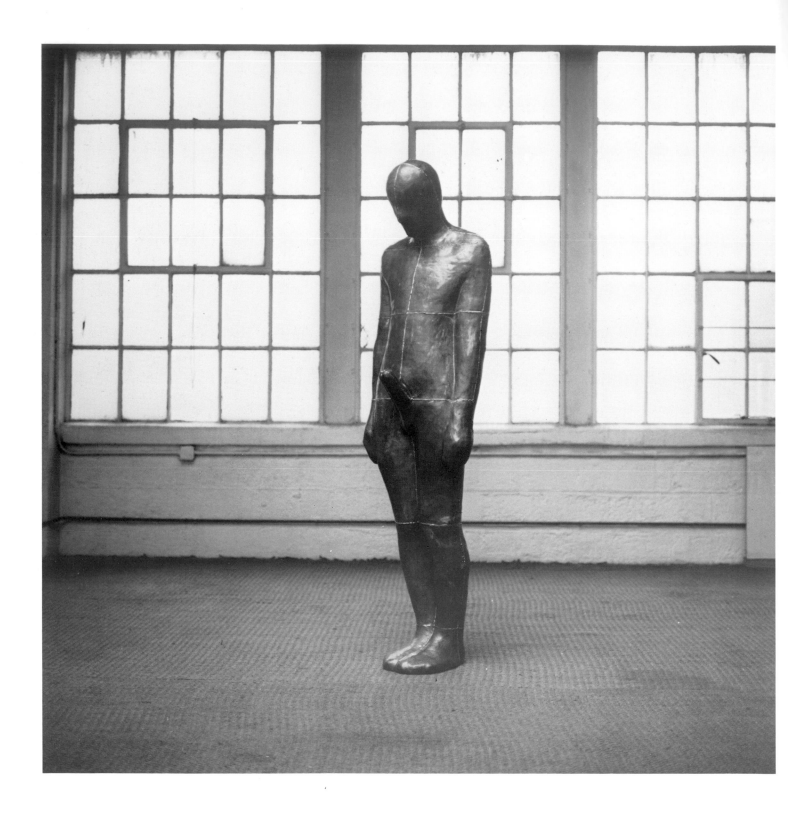

32 Peer

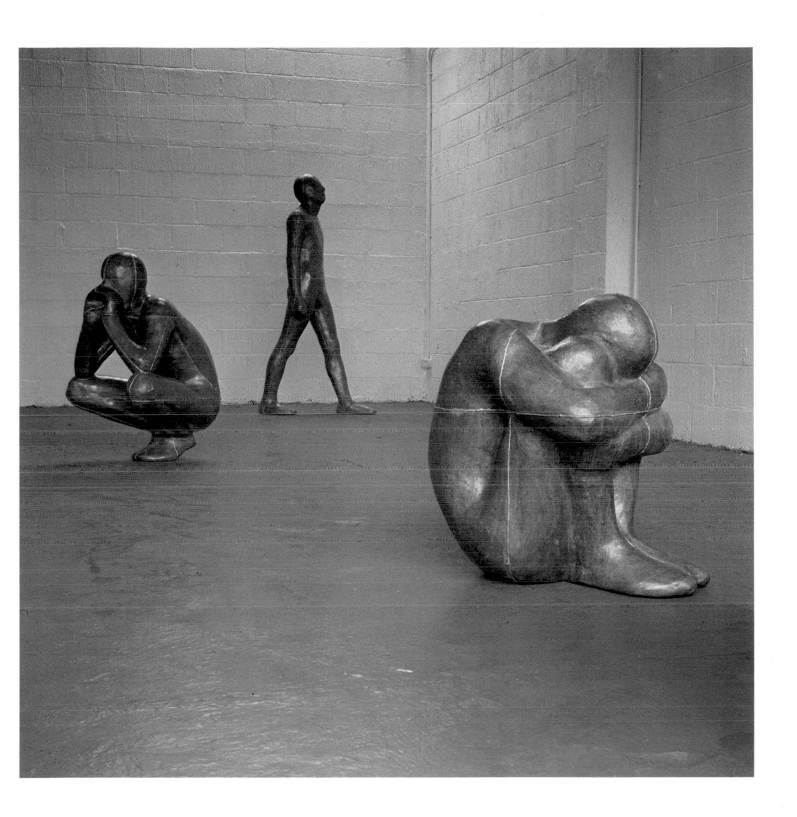

33 Three Calls: Pass, Cast and Plumb

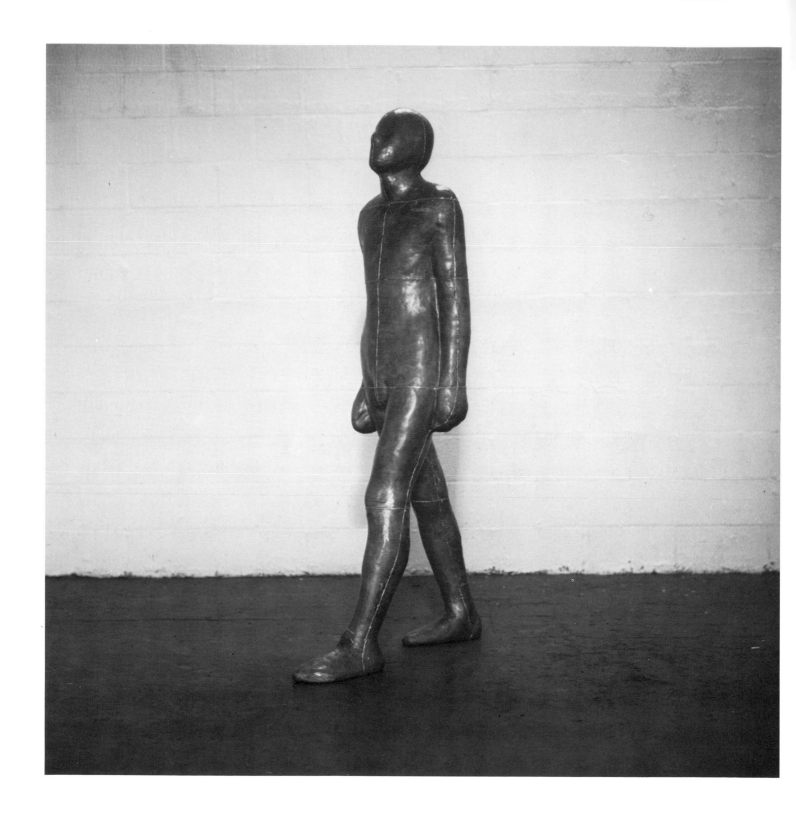

34 Pass

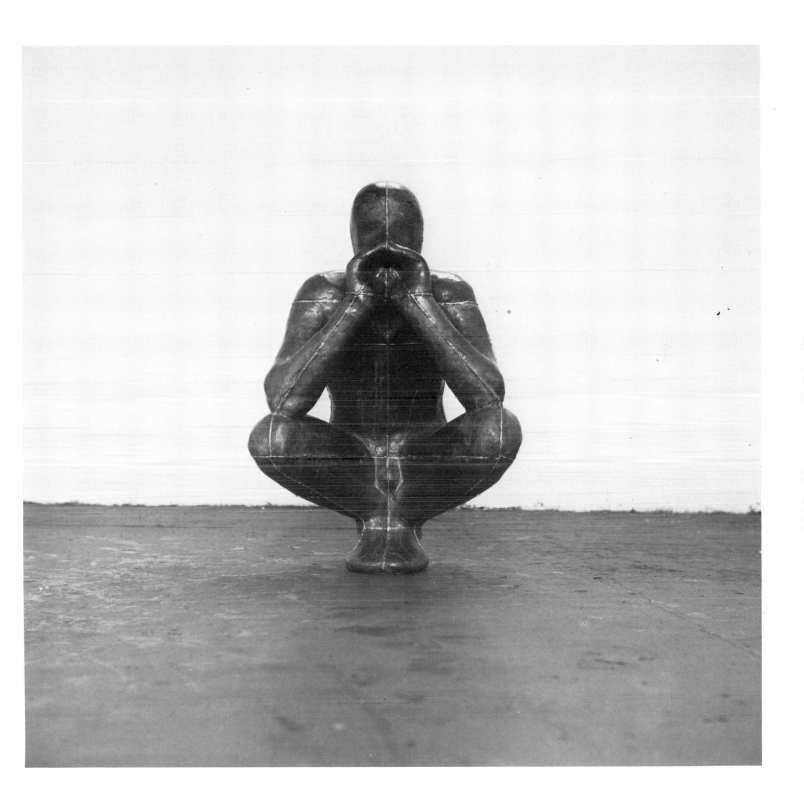

35 Cast

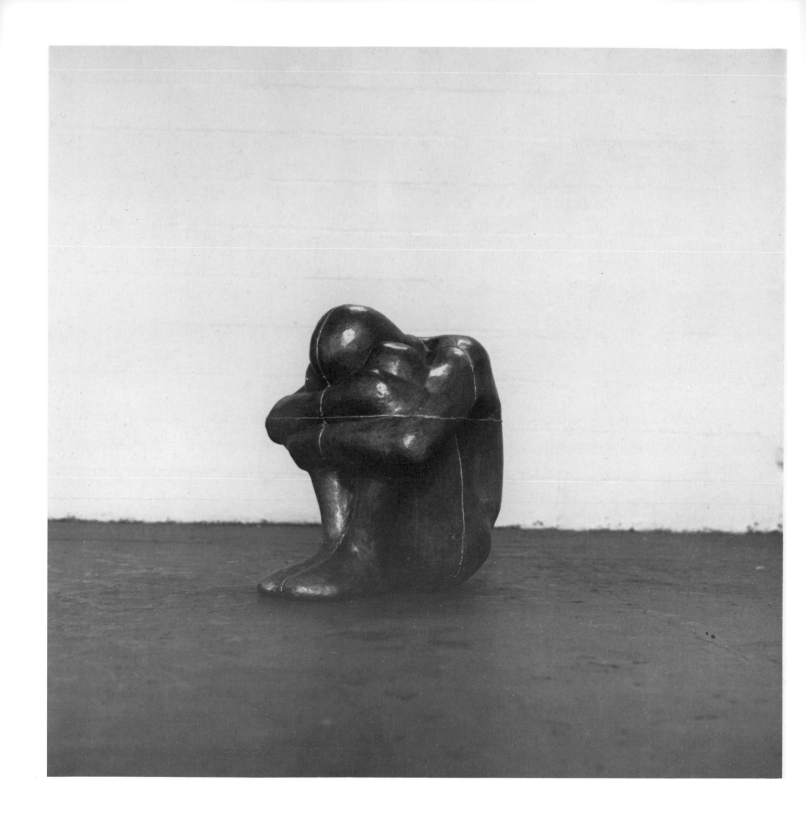

36 Plumb

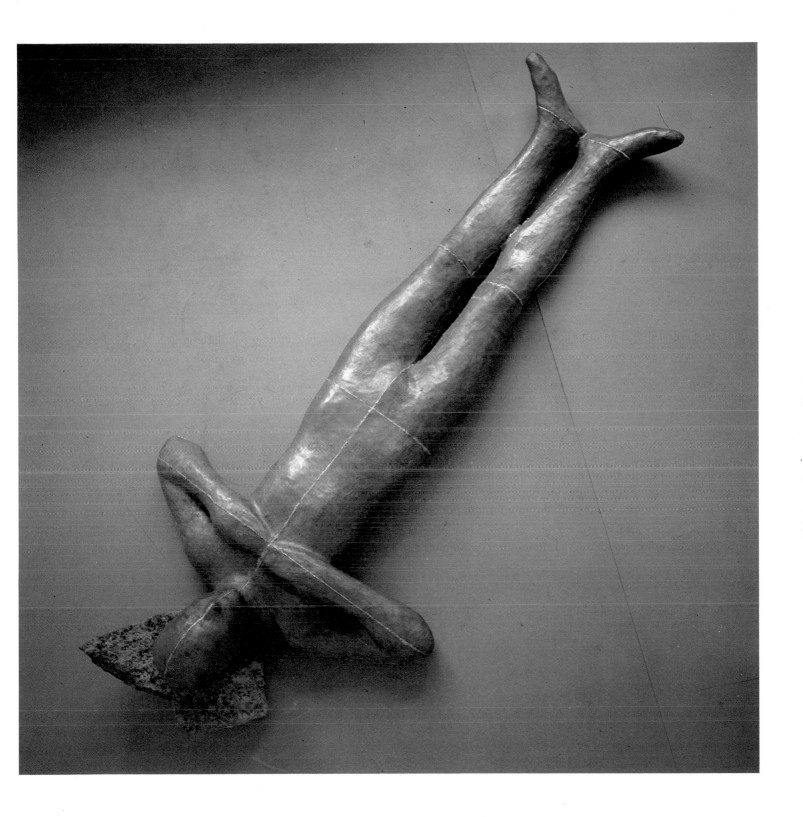

37 Untitled (Sleeping Figure)

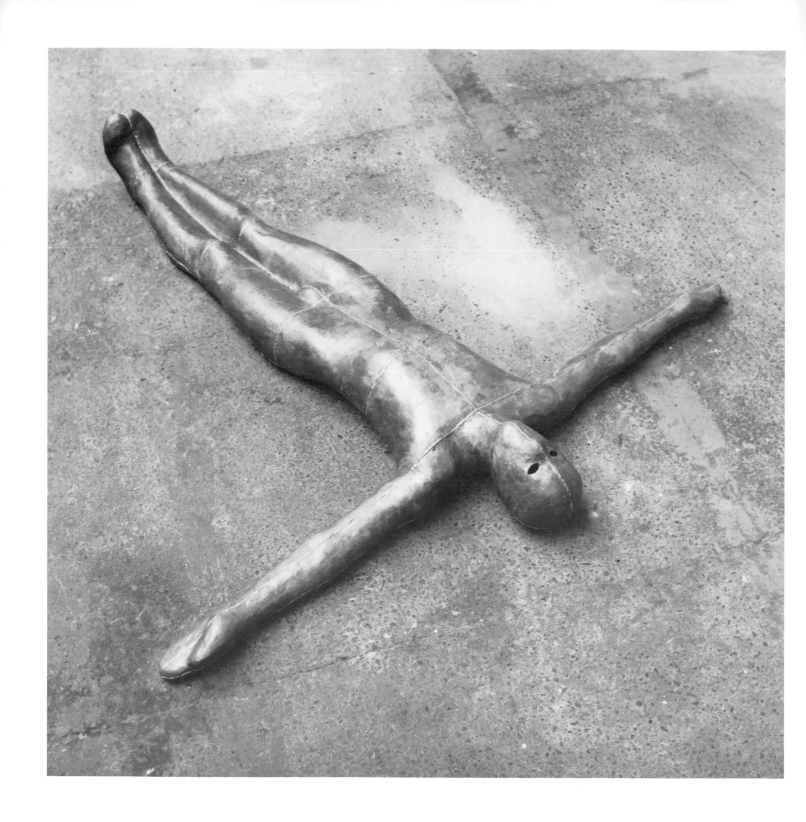

38 Fill

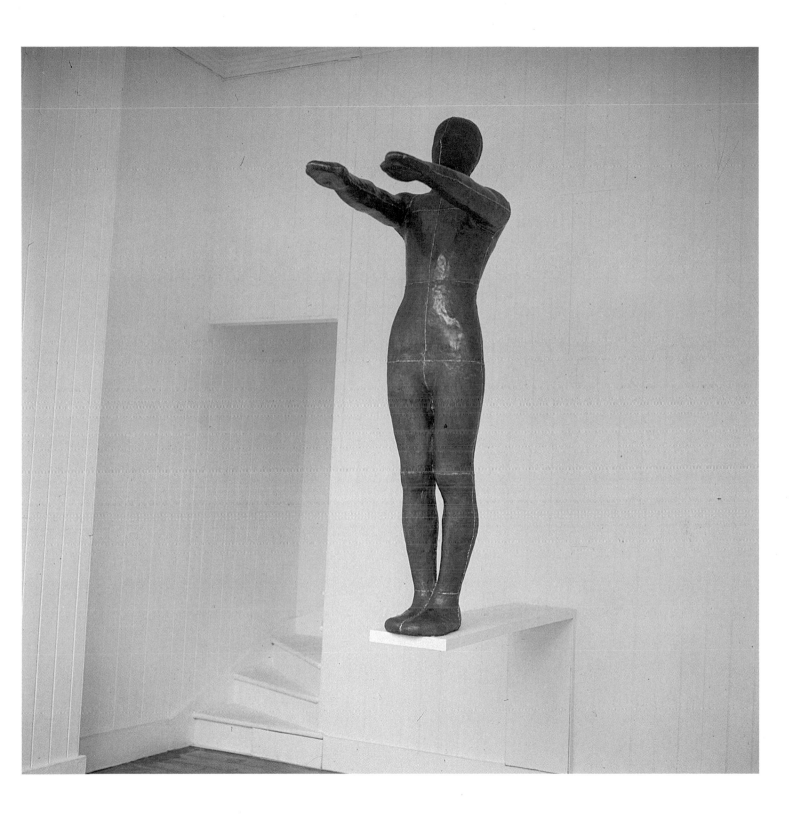

39 Untitled (Diving Figure)

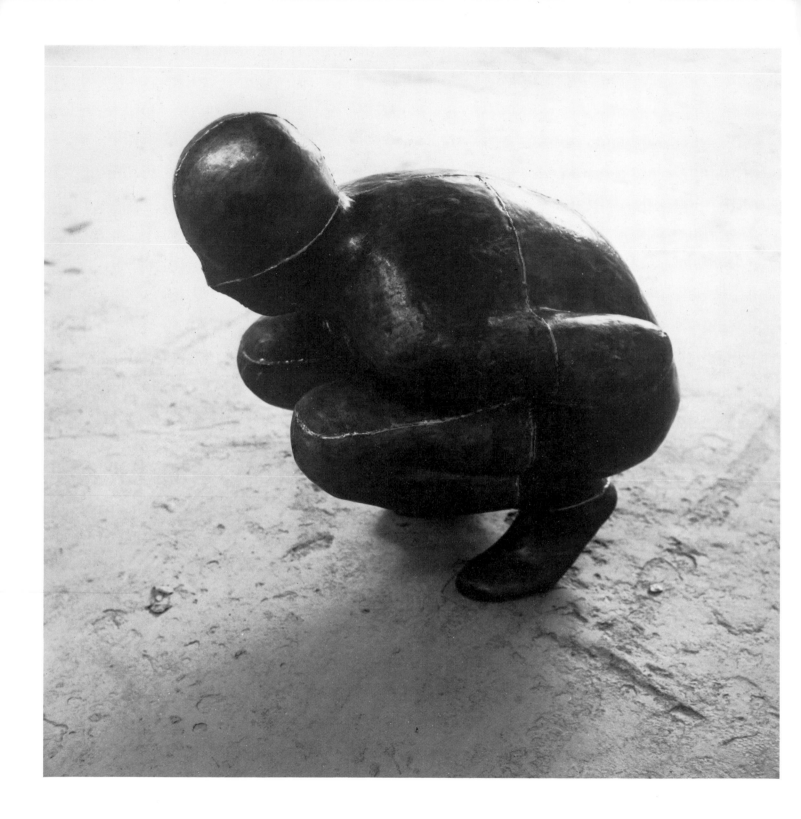

40 Proof

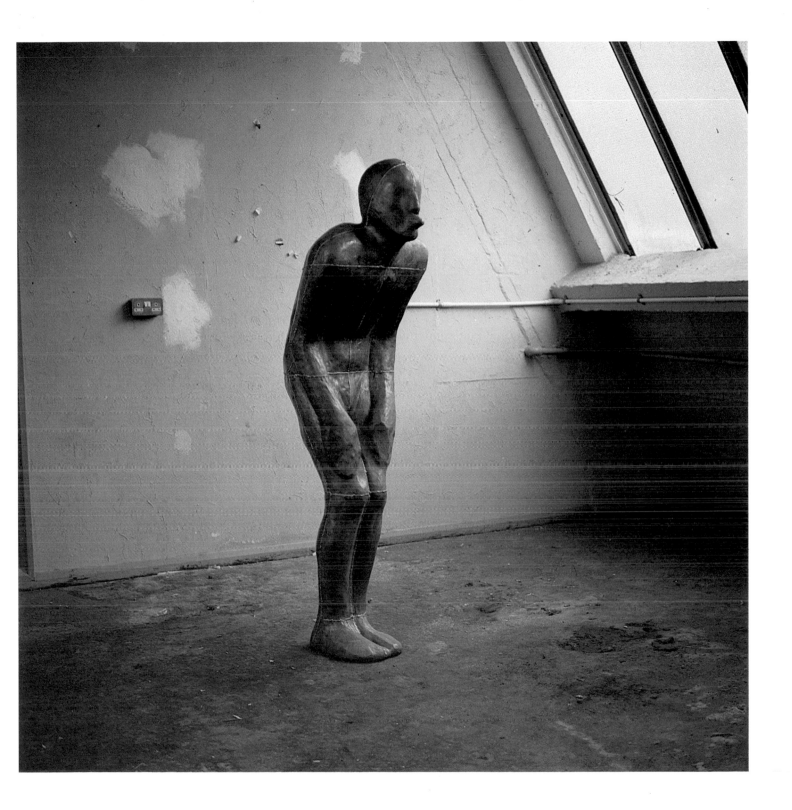

41 Address

All photographs by Antony Gormley except: Kevin Cummings 24, Antonia Reeve 4, 15, David Scott 25, David Scott & Belinda Parsons 31, 32, 33, 34, 35, 36, 37, 38, 39, 41, Edward Woodman 7.

ILLUSTRATIONS

1 Sleeping Place 1973
Terracotta, Tissue Paper and Dope
approx 5 × 14 × 8cms Destroyed

2 Sleeping Place 1974
Linen and Plaster
approx 40 × 115 × 76cms Destroyed

3 Sleeping Place 1974
Cotton and Plaster
approx 60 × 150 × 70cms Destroyed

4 Full Bowl 1977
Lead
6 × 17 × 17cms

5 Breadline 1979
Bread
approx 0.8 × 1500 × 3cms Destroyed

6 Land, Sea and Air I 1977-9
Lead, Stone, Water and Air
Each unit approx 20 × 31 × 24cms

7 Fruits of the Earth 1978-9
Lead, Revolver, Bottle, Wine, Machete
Longest element approx 60cms

8 Bed 1981
Bread and Wax
28 × 220 × 168cms

9 Room 1980-1
 1 Jacket, 1 Pullover, 1 Shirt, 1 Vest, 1 pr Pants, 1 pr Trousers, 1 pr Socks
 and 1 pr Shoes cut into 8mm strips to form enclosure
 193 × 610 × 610cms

10 Three Bodies 1981
 Lead, Fibreglass and Earth
 Rock: 96 × 60 × 54cms Shark: 18 × 193 × 60cms Pumpkin: 50 × 50 × 44cms
 Salvatore Ala Gallery, New York

11 Three Ways: Mould, Hole and Passage 1981-2
 Lead and Plaster
 For dimensions see following

12 Mould 1981
 Lead and Plaster
 60 × 98 × 50cms

13 Passage 1982
 Lead and Plaster
 34 × 209 × 50cms

14 Hole 1982
 Lead and Plaster
 62 × 123 × 80cms

15 Five Fishes 1982
 Lead, Sword, Fish, Artillery Shell, Truncheon, Cucumber
 Fish: 70cms long

16 Mothers Pride 1982
 Bread and Wax
 305 × 190 × 0.8cms

17 Land, Sea and Air II 1982
Lead and Fibreglass
For dimensions see following
Private collection, New York

18 Land 1982
Lead and Fibreglass
45 × 103 × 53cms

19 Sea 1982
Lead and Fibreglass
191 × 50 × 32cms

20 Air 1982
Lead and Fibreglass
118 × 69 × 52cms

21 Islands 1982
Lead, Vegetables and Organs
Largest unit 9 × 16 × 13cms

22 Still Falling 1983
Portland Stone: Tout Quarries, Dorset
203 × 50 × 15cms

23 Man: Rock 1982
Portland Stone
51 × 73 × 65cms

24 Man: Rock 1982
Portland Stone
128 × 104 × 63cms

31 Desert (for Walter) 1983
Lead and Fibreglass
22 × 215 × 126
Private Collection, New York

32 Peer 1983-4
Lead, Plaster and Fibreglass
188 × 50 × 43cms

33 Three Calls: Pass, Cast and Plumb 1983-4
Lead, Plaster, Air and Fibreglass
For dimensions see following

34 Pass 1983-4
Lead, Plaster, Air and Fibreglass
190 × 56 × 95cms

35 Cast 1983-4
Lead, Plaster and Fibreglass
101 × 68 × 66cms

36 Plumb 1984
Lead, Plaster, Air and Fibreglass
70 × 57 × 74cms

37 Untitled (Sleeping Figure) 1983
Lead, Plaster, Granite and Fibreglass
33 × 212 × 93cms
Private Collection, New York

38 Fill 1984
Lead, Plaster and Fibreglass
25 × 203 × 205cms

39 Untitled (Diving Figure) 1983
Lead, Plaster, Air and Fibreglass
Board: 76 × 137 × 25cms Figure: 78 × 40 × 22cms
Southampton City Art Gallery

40 Proof 1984
Lead, Plaster, Air and Fibreglass
80 × 56 × 80cms

41 Address 1984
Lead, Plaster, Air and Fibreglass
168 × 50 × 66cms

Cover: Man 1981
Charcoal on paper
85 × 58cms

Frontis: Head 1981
Charcoal and oil on paper
85 × 58cms

Opposite: Mould 1981
Charcoal and oil on paper
58 × 85cms

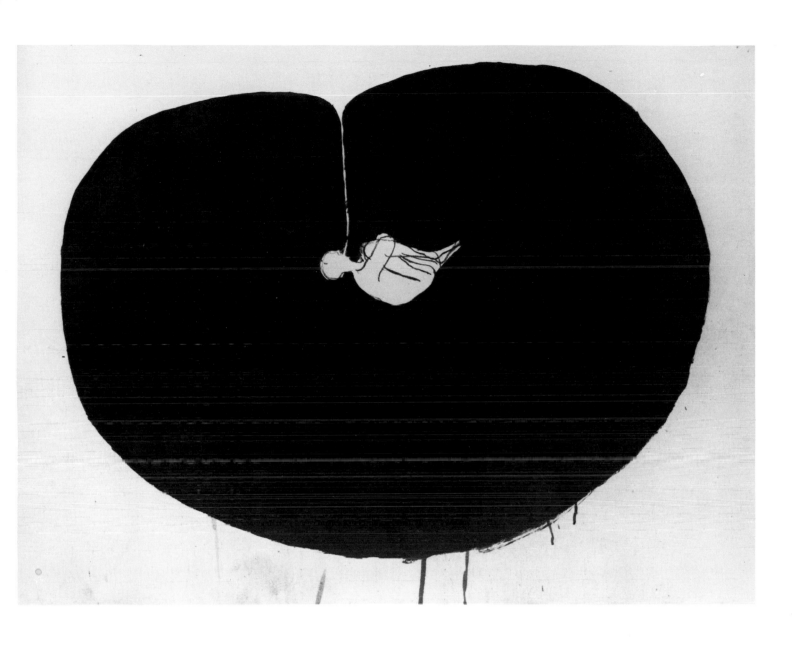